Come Play with Me

Trevor Murray

authorHOUSE

AuthorHouse™
1663 Liberty Drive
Bloomington, IN 47403
www.authorhouse.com
Phone: 1 (800) 839-8640

© 2015 Trevor Murray. All rights reserved.

No part of this book may be reproduced, stored in a retrieval system, or transmitted by any means without the written permission of the author.

Published by AuthorHouse 11/11/2015

ISBN: 978-1-5049-5960-5 (sc)
ISBN: 978-1-5049-5959-9 (e)

Library of Congress Control Number: 2015918198

Print information available on the last page.

Any people depicted in stock imagery provided by Thinkstock are models, and such images are being used for illustrative purposes only.
Certain stock imagery © Thinkstock.

This book is printed on acid-free paper.

Because of the dynamic nature of the Internet, any web addresses or links contained in this book may have changed since publication and may no longer be valid. The views expressed in this work are solely those of the author and do not necessarily reflect the views of the publisher, and the publisher hereby disclaims any responsibility for them.

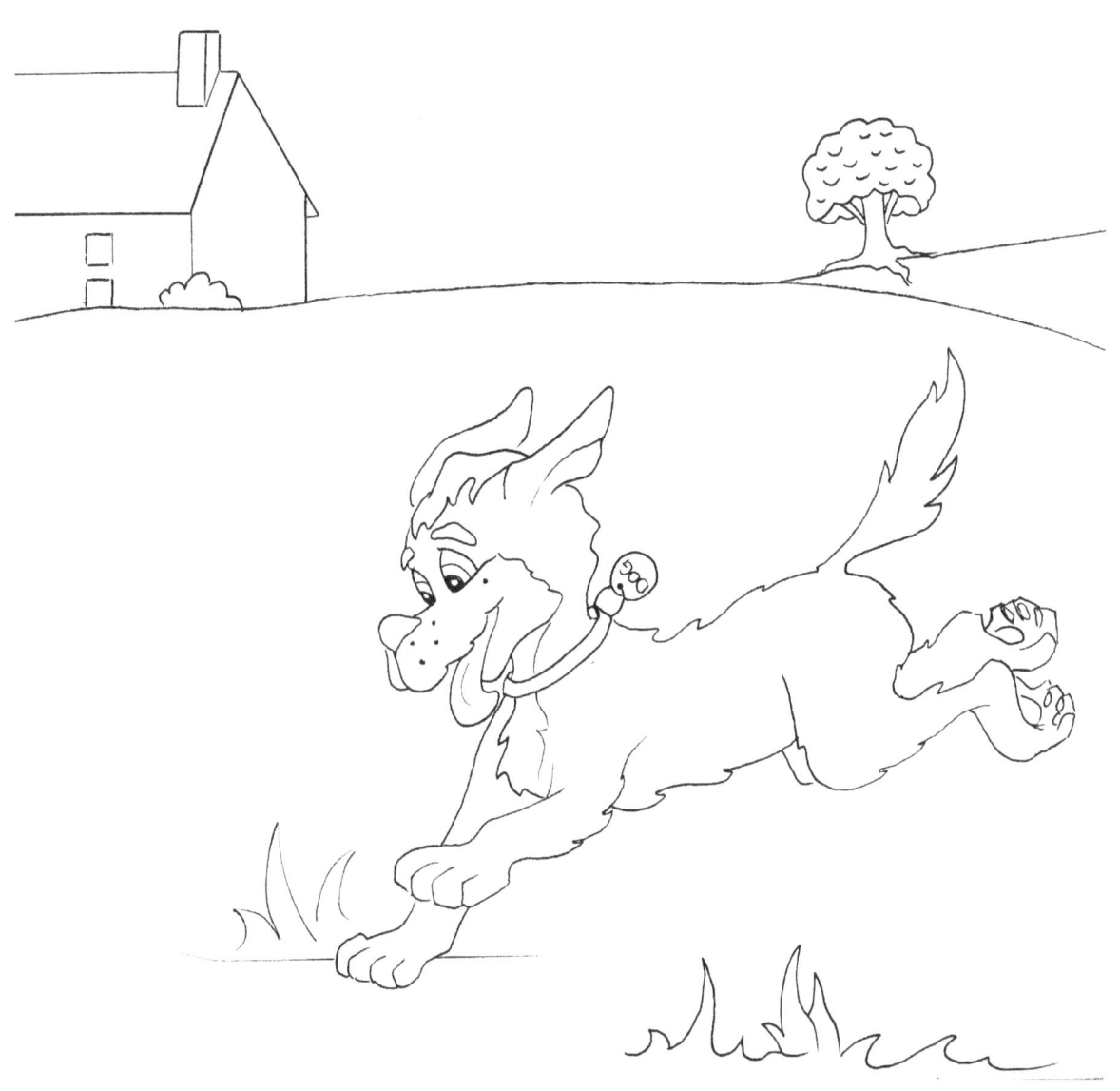

The _____ Dog ran across the yard.

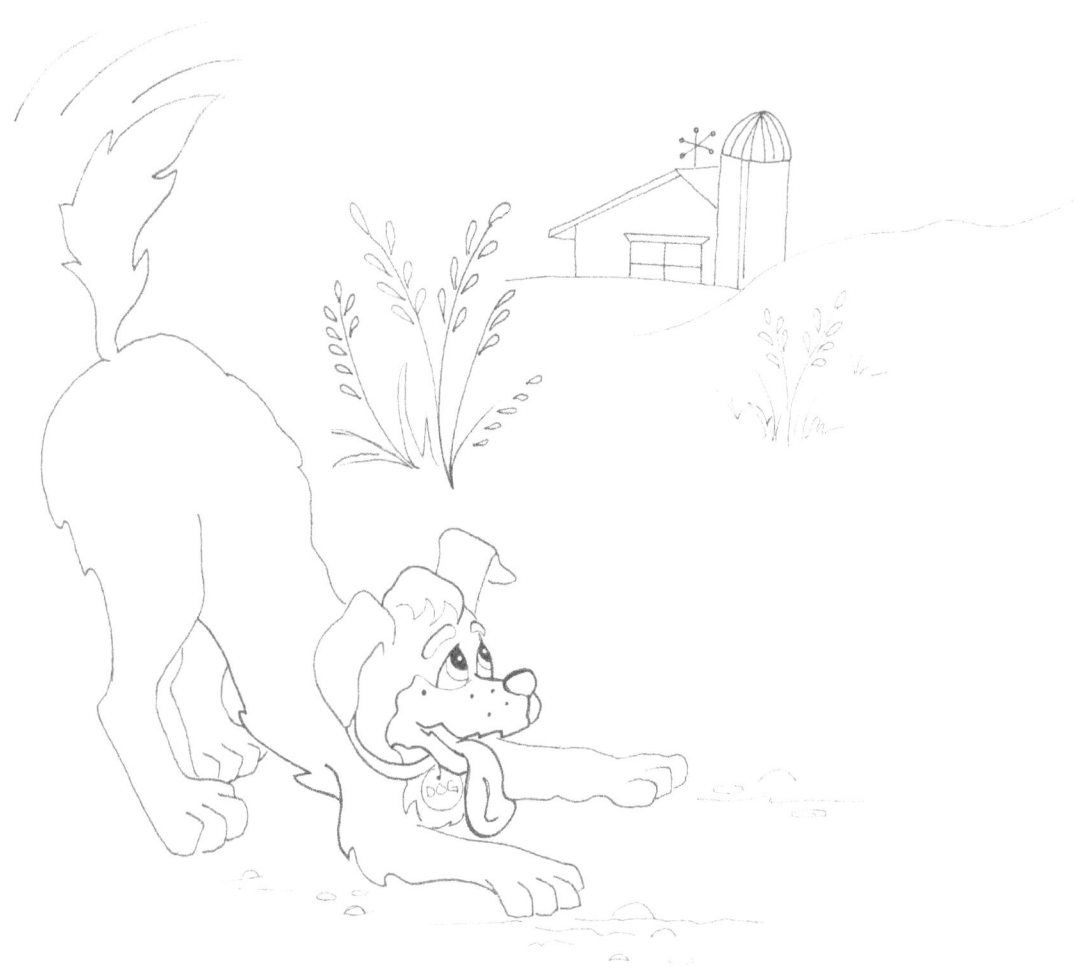

"Let's play!" said the Dog.

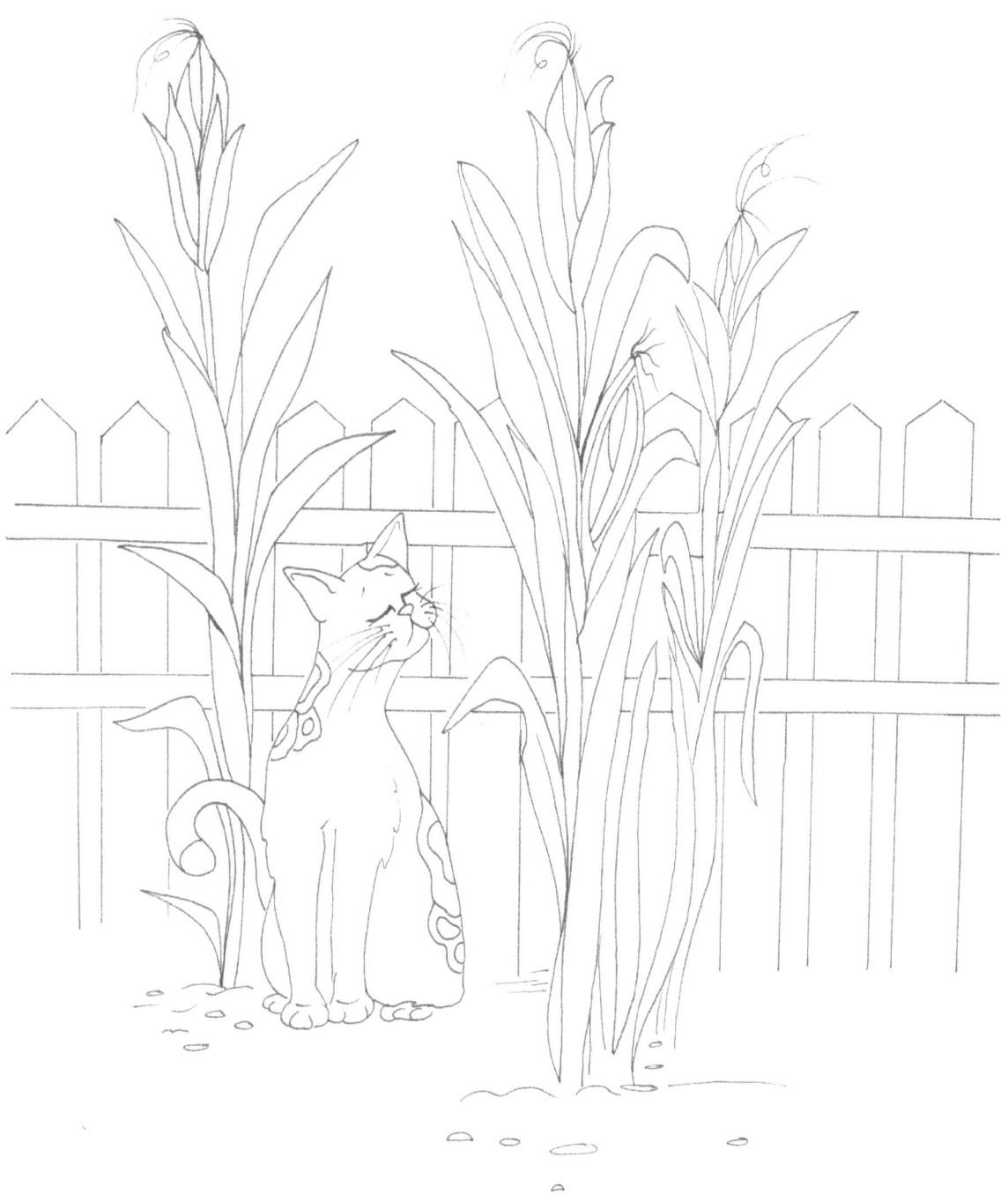

But the _____ Cat didn't want to play.

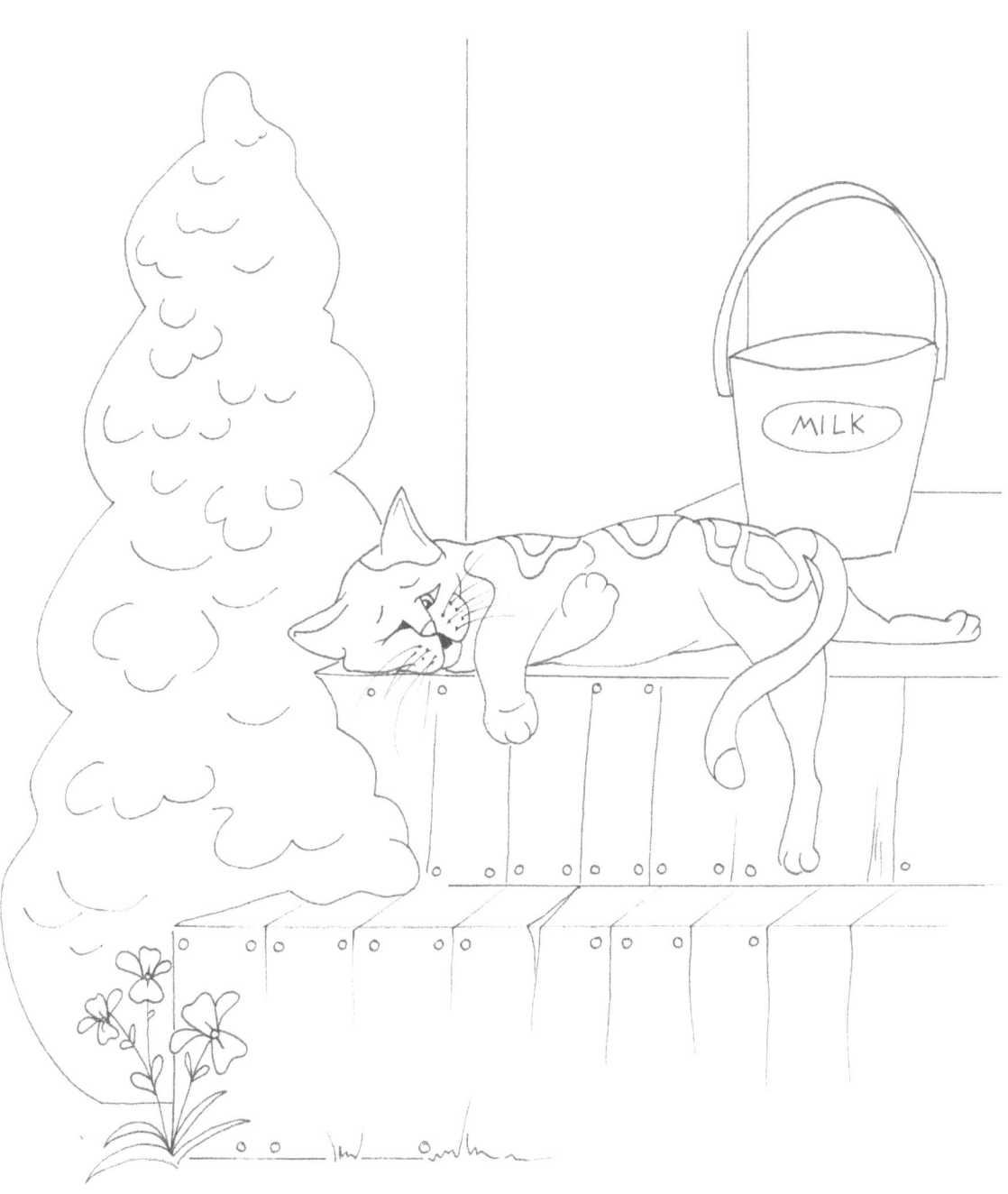

"I want to relax," said the Cat.

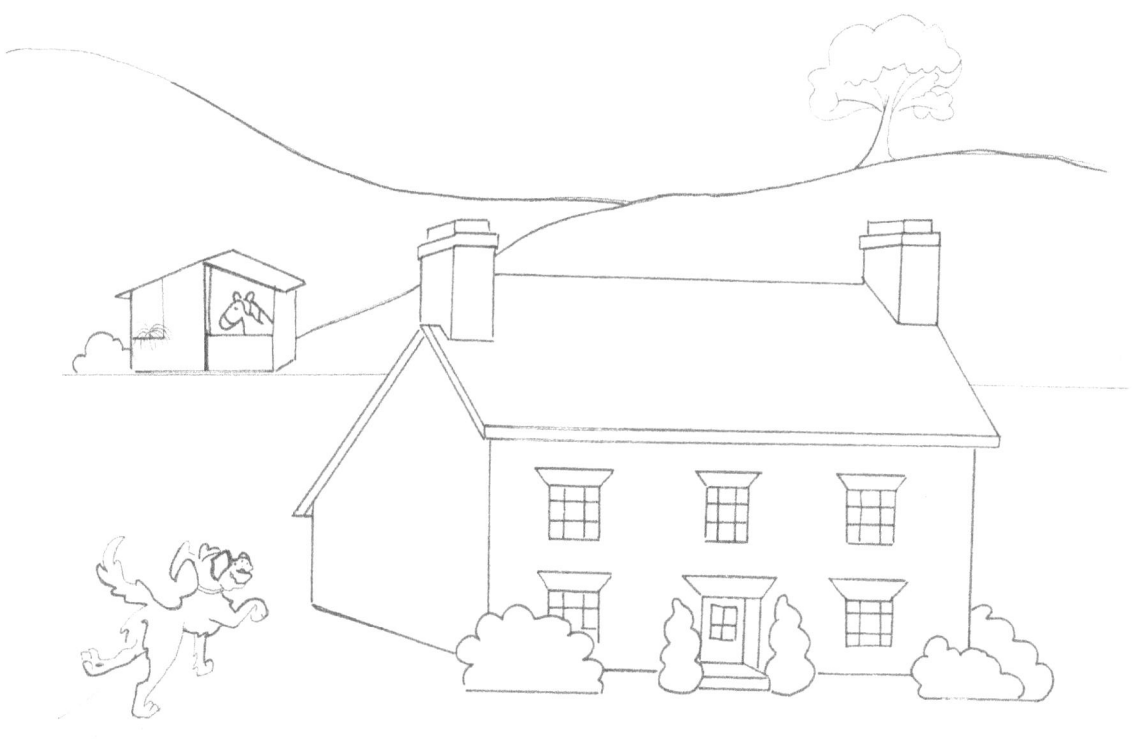

So the _____ Dog ran behind the house.

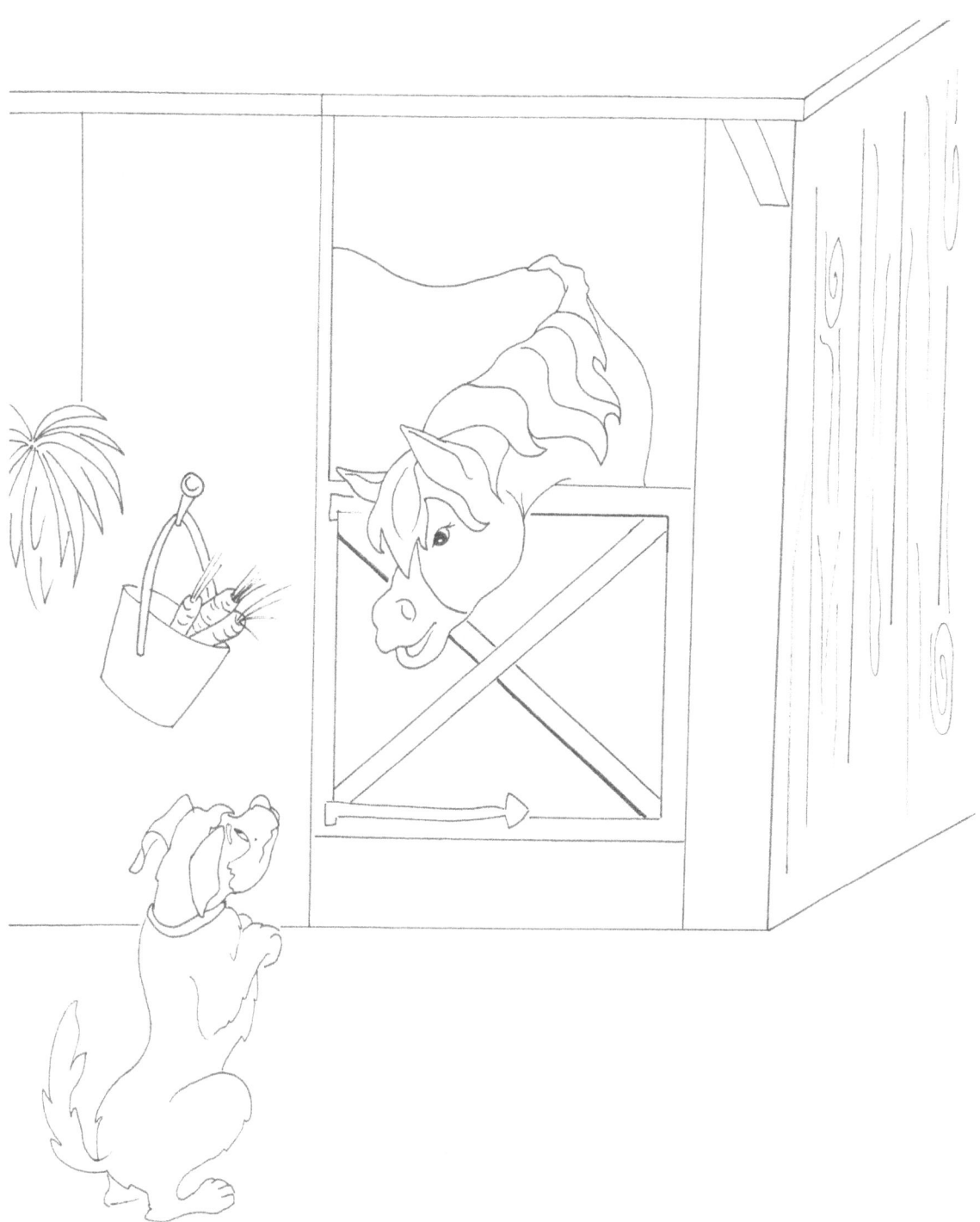

"Do you want to play with me?" asked the Dog.

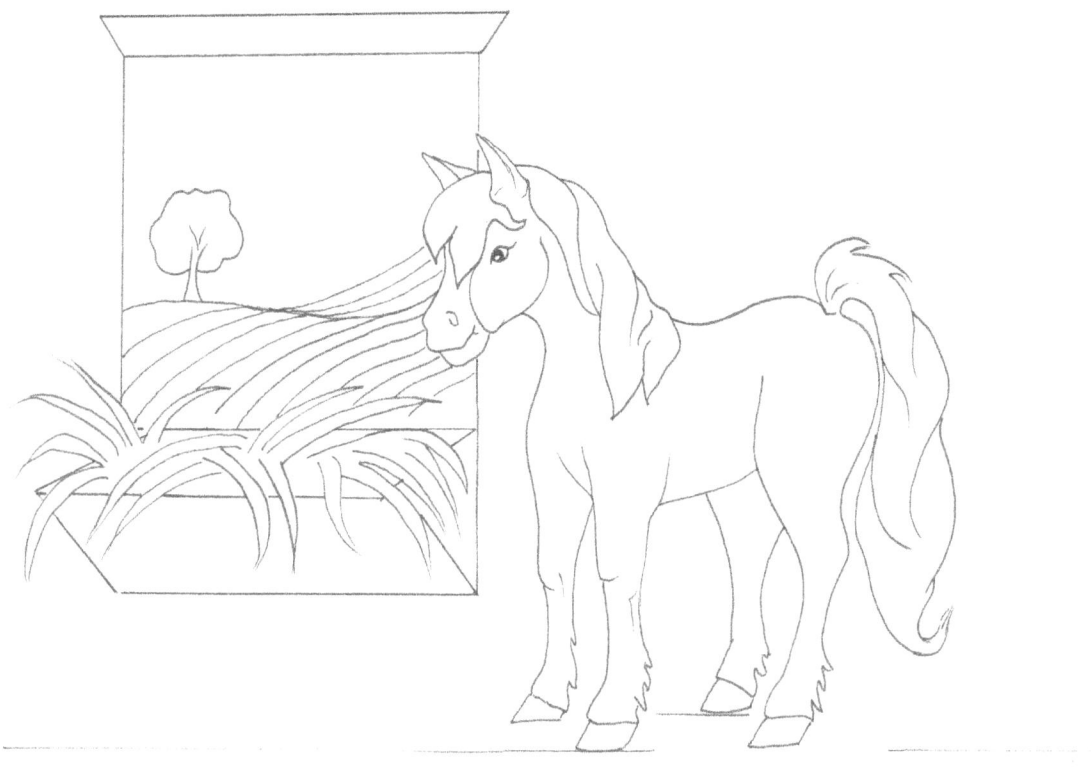

"I'm hungry," said the _____ Horse. "I want to eat."

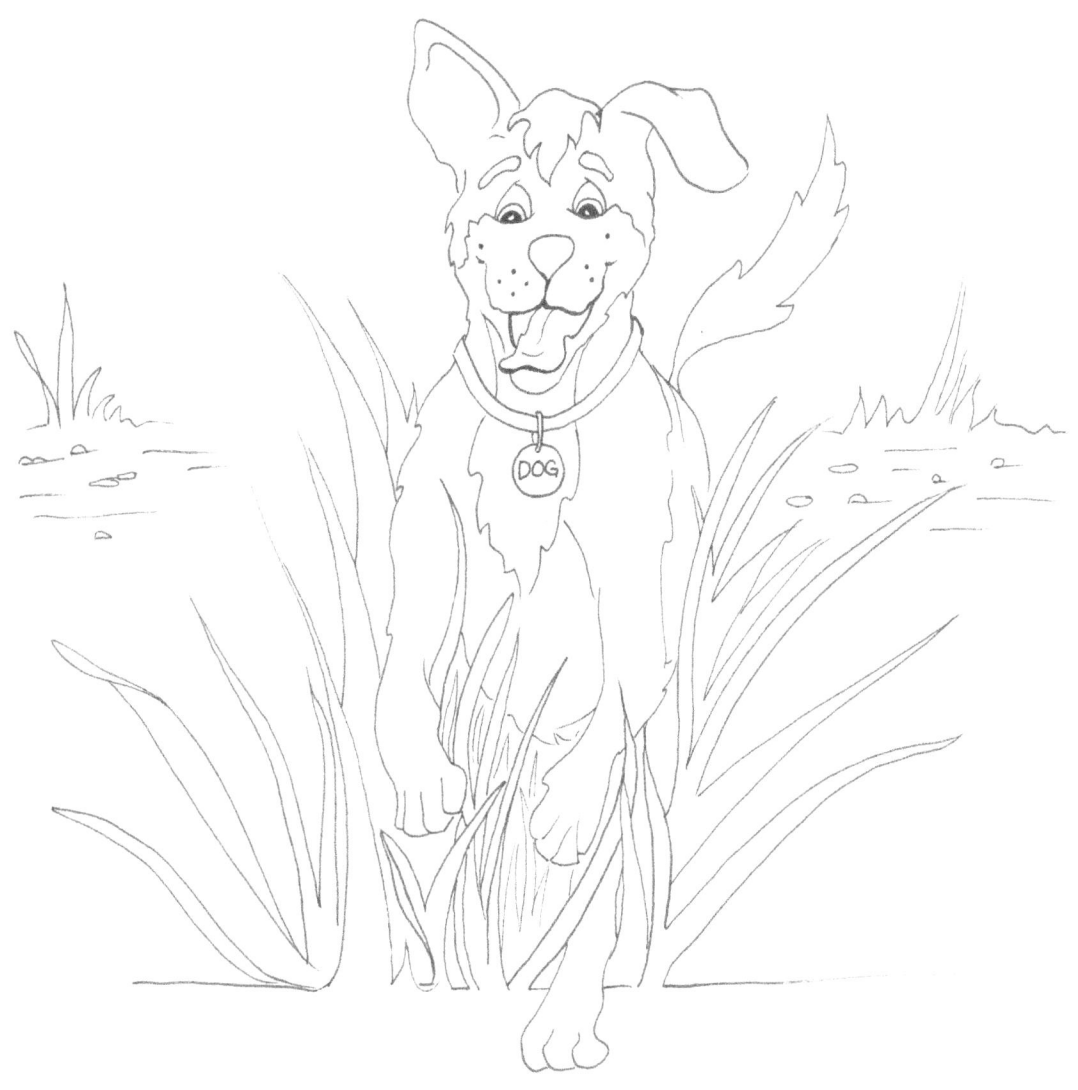

So the Dog ran across the street.

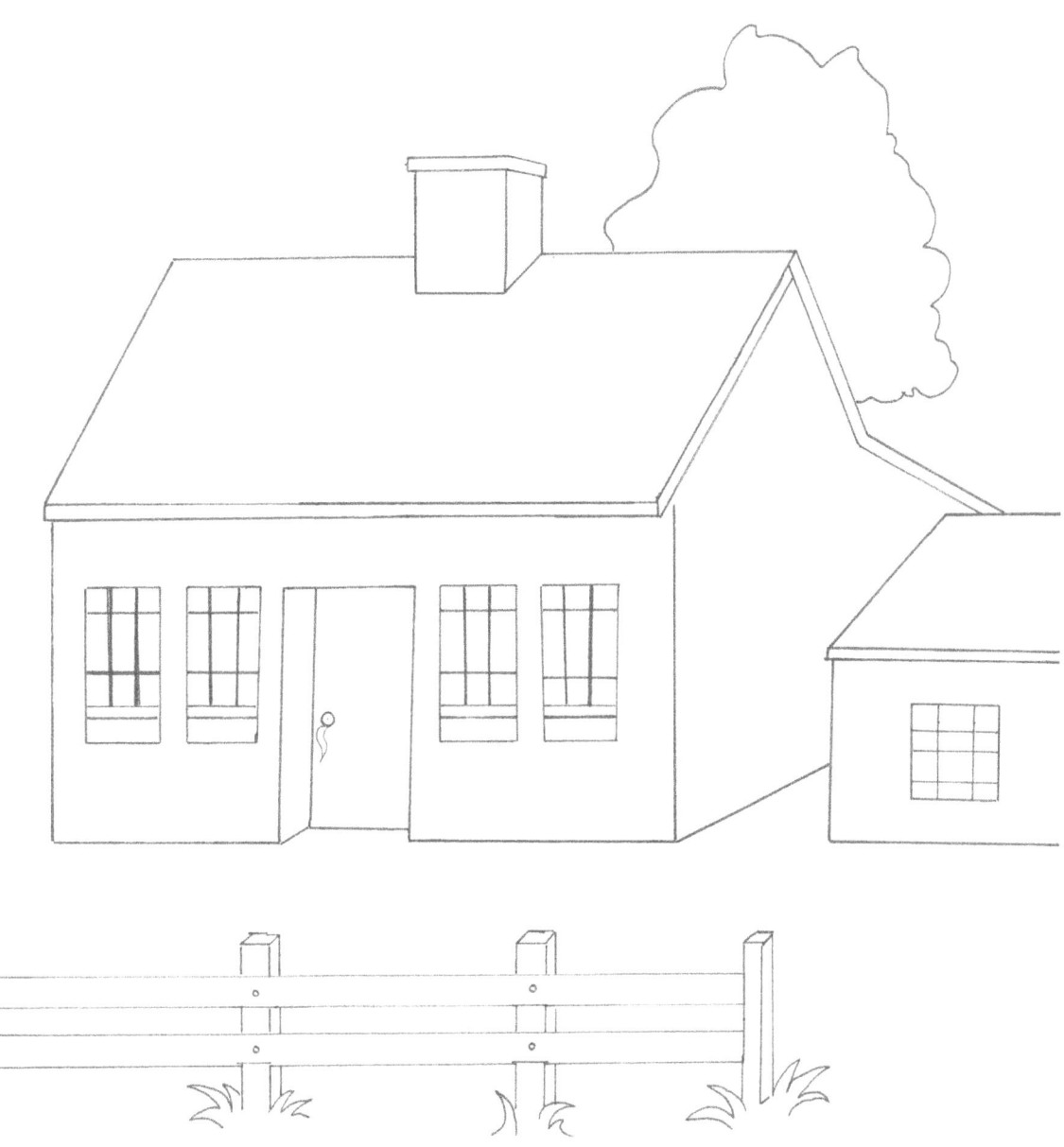

To the neighbor's house, the _____ Dog went.

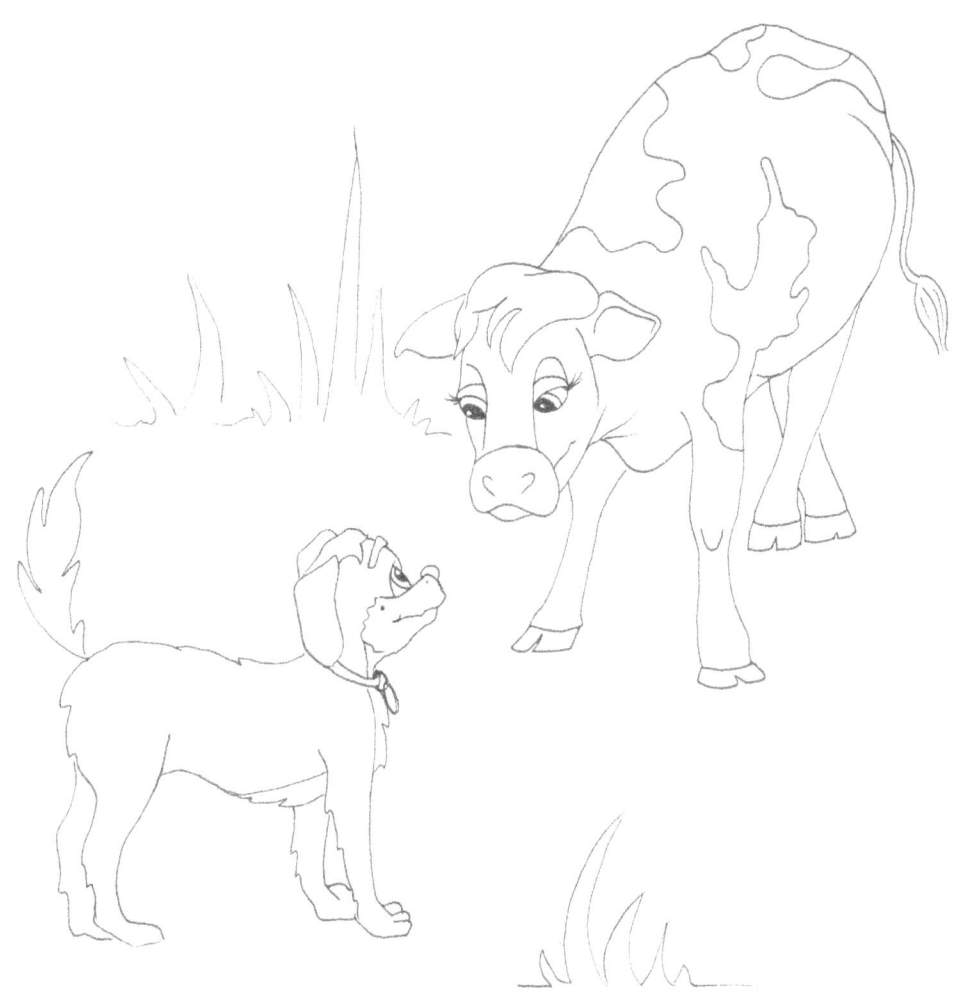

"Do you wanna play with me?" asked the Dog.

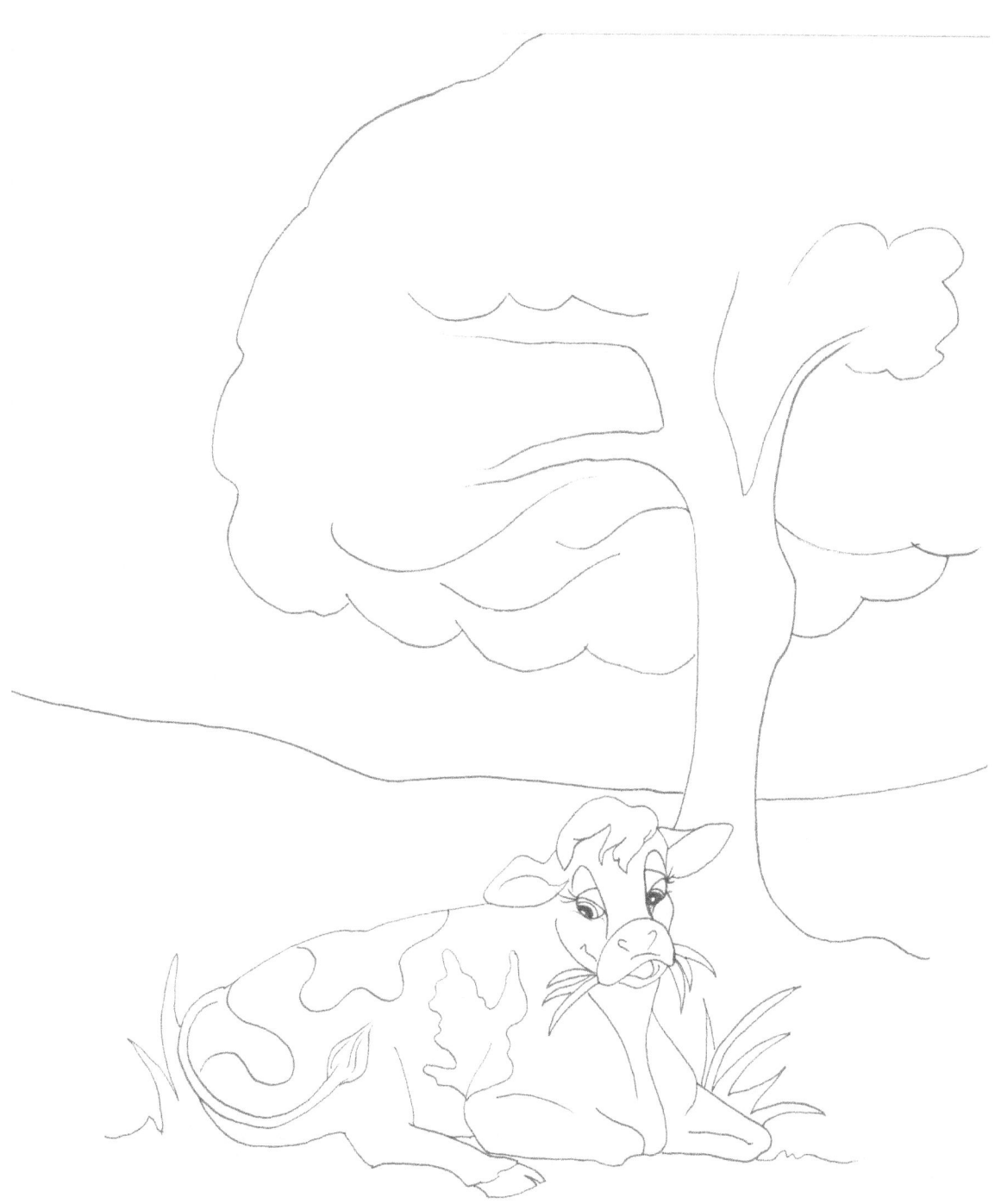

"I've been out in the sun all day. I really just want to rest," said the _____ Cow.

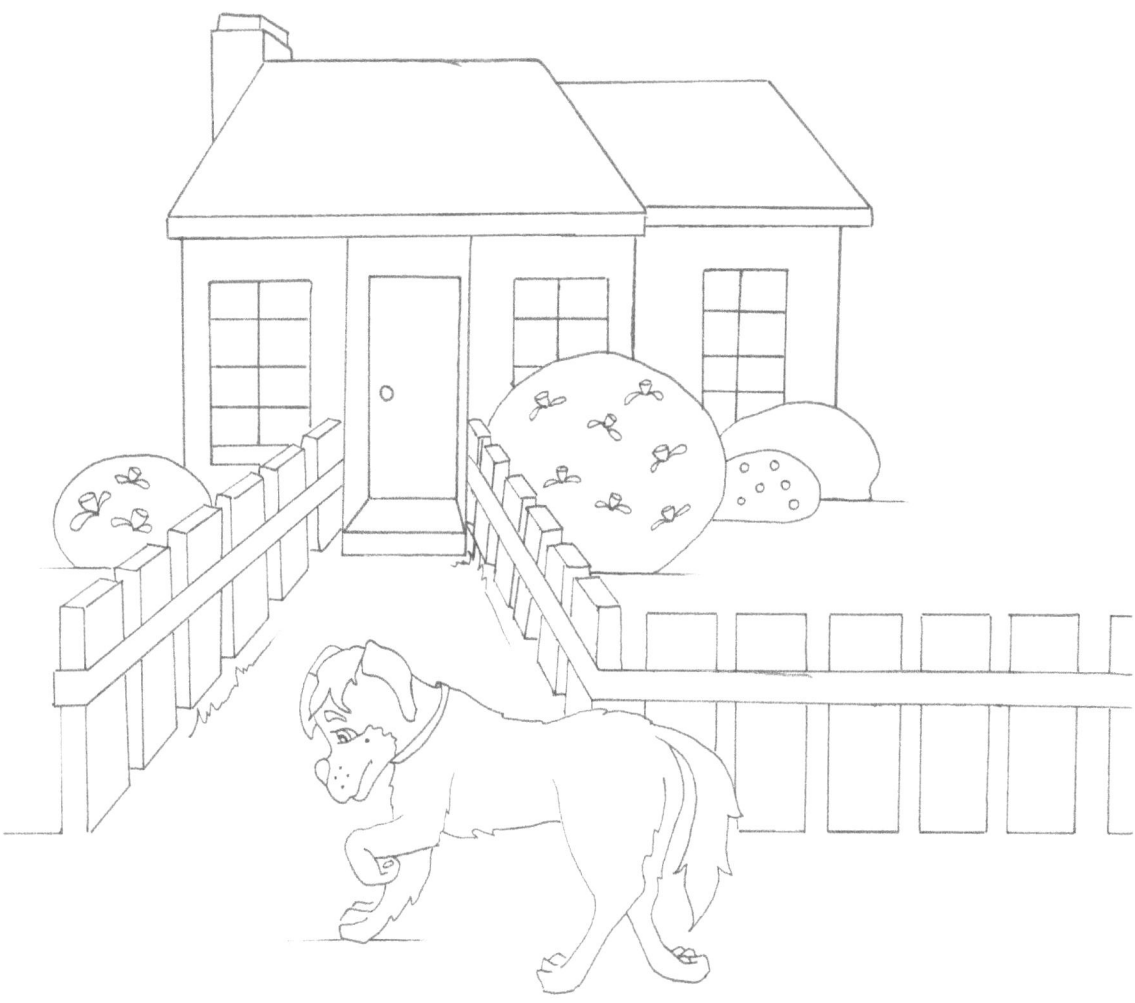

Disappointed, the _____ Dog walked back home.

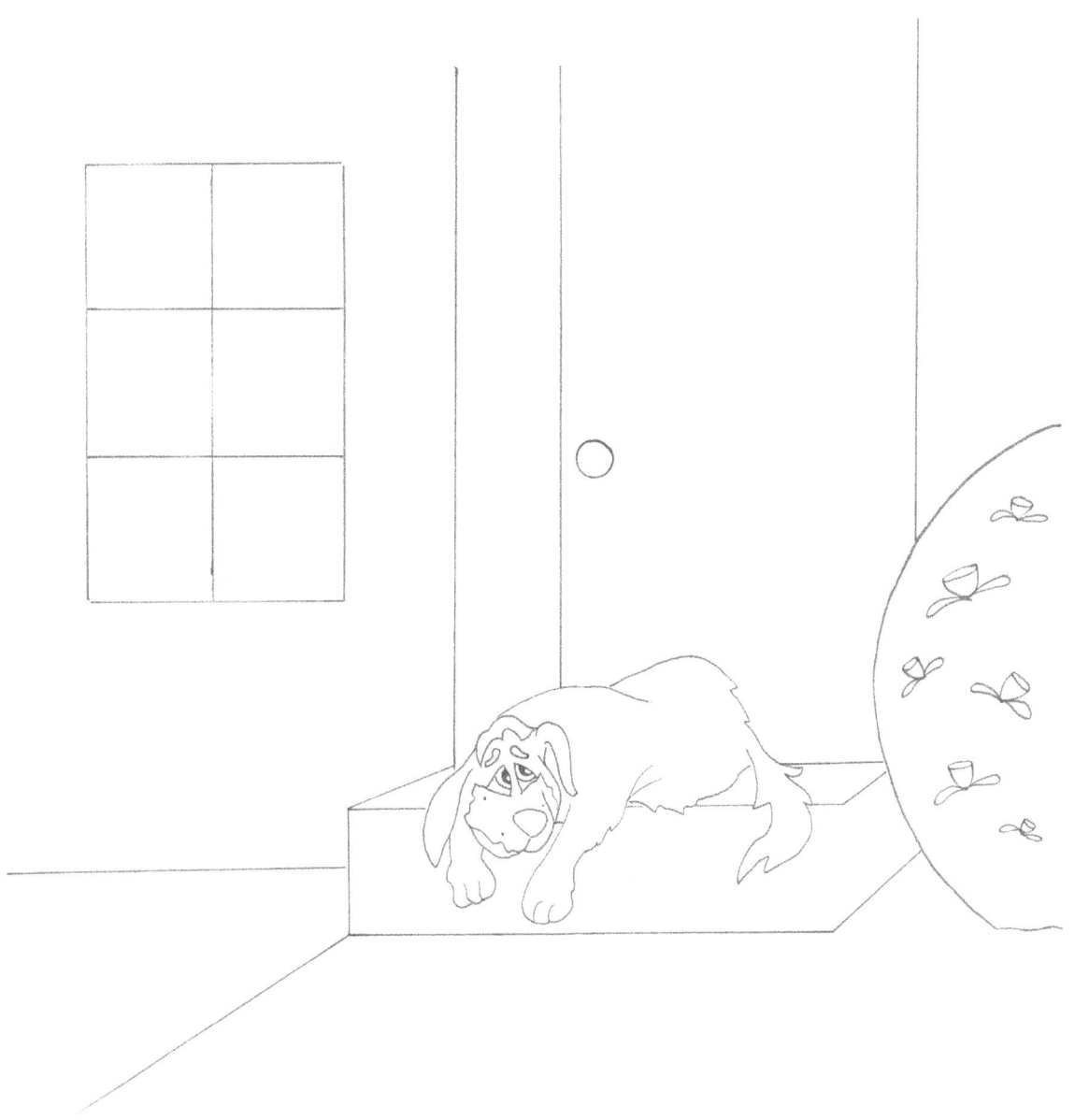

"No one wants to play with me", the _____ Dog sighed.

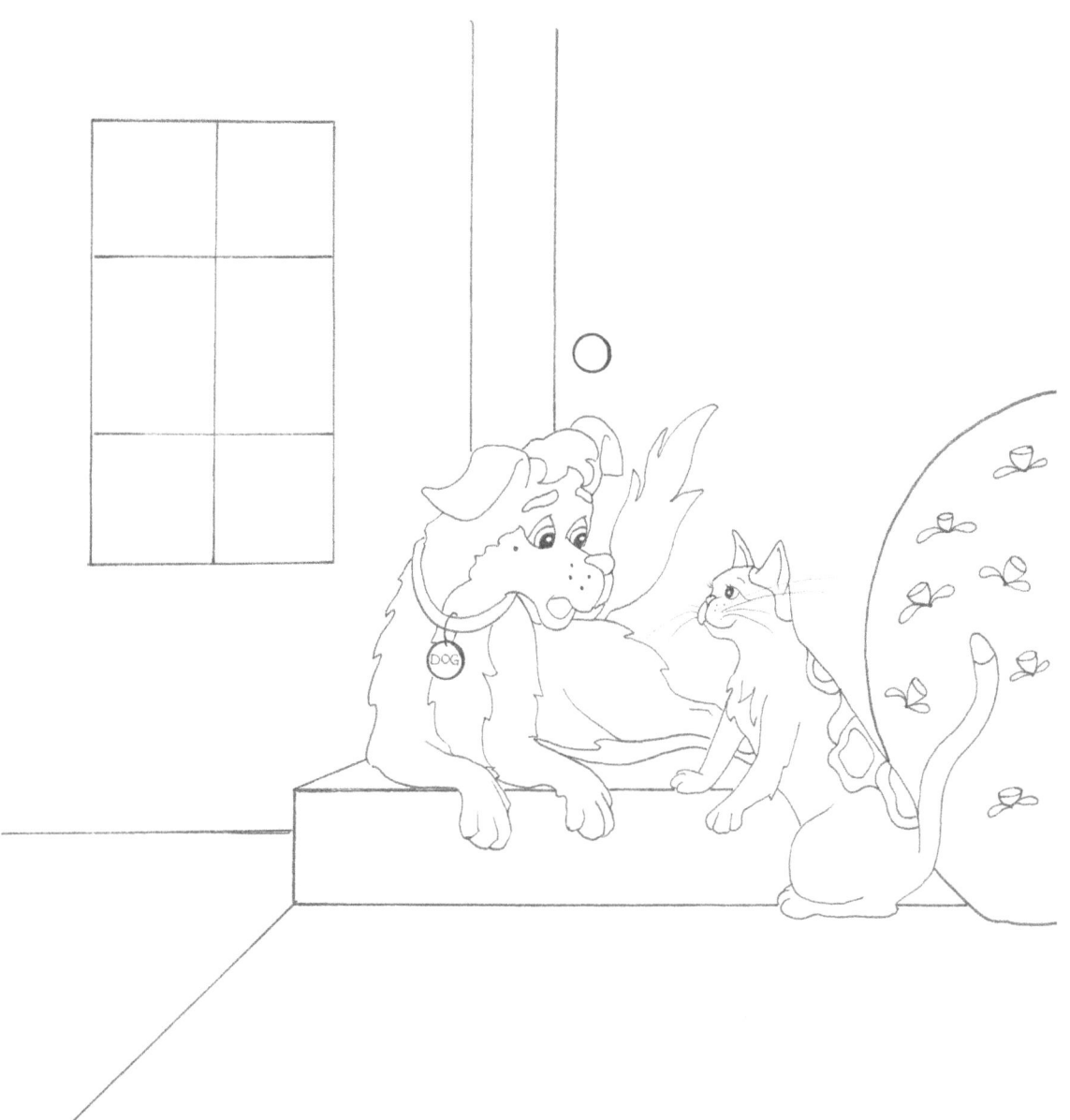

"I'll play with you now," said the _____ Cat.

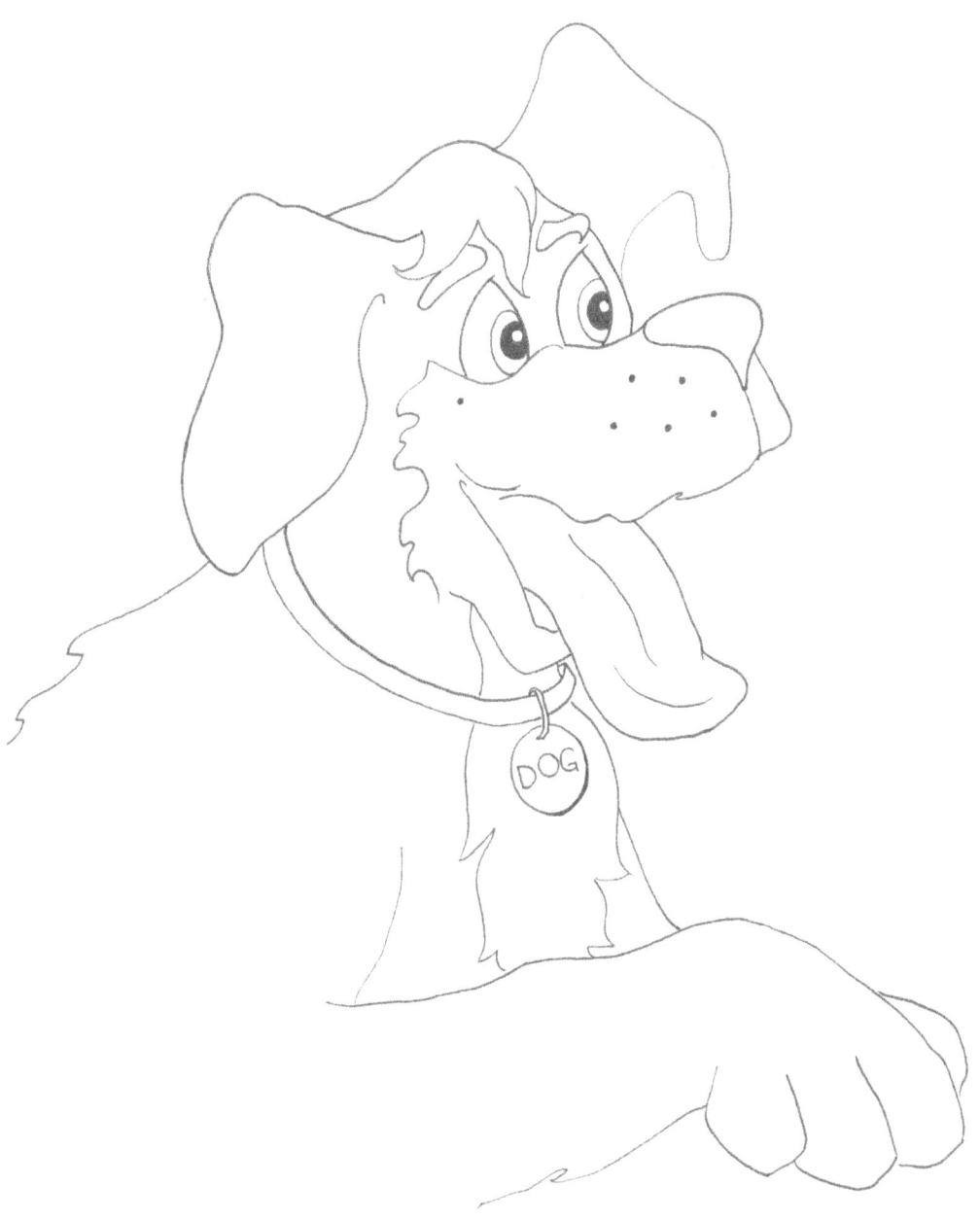

"You will?" asked the _____ Dog.

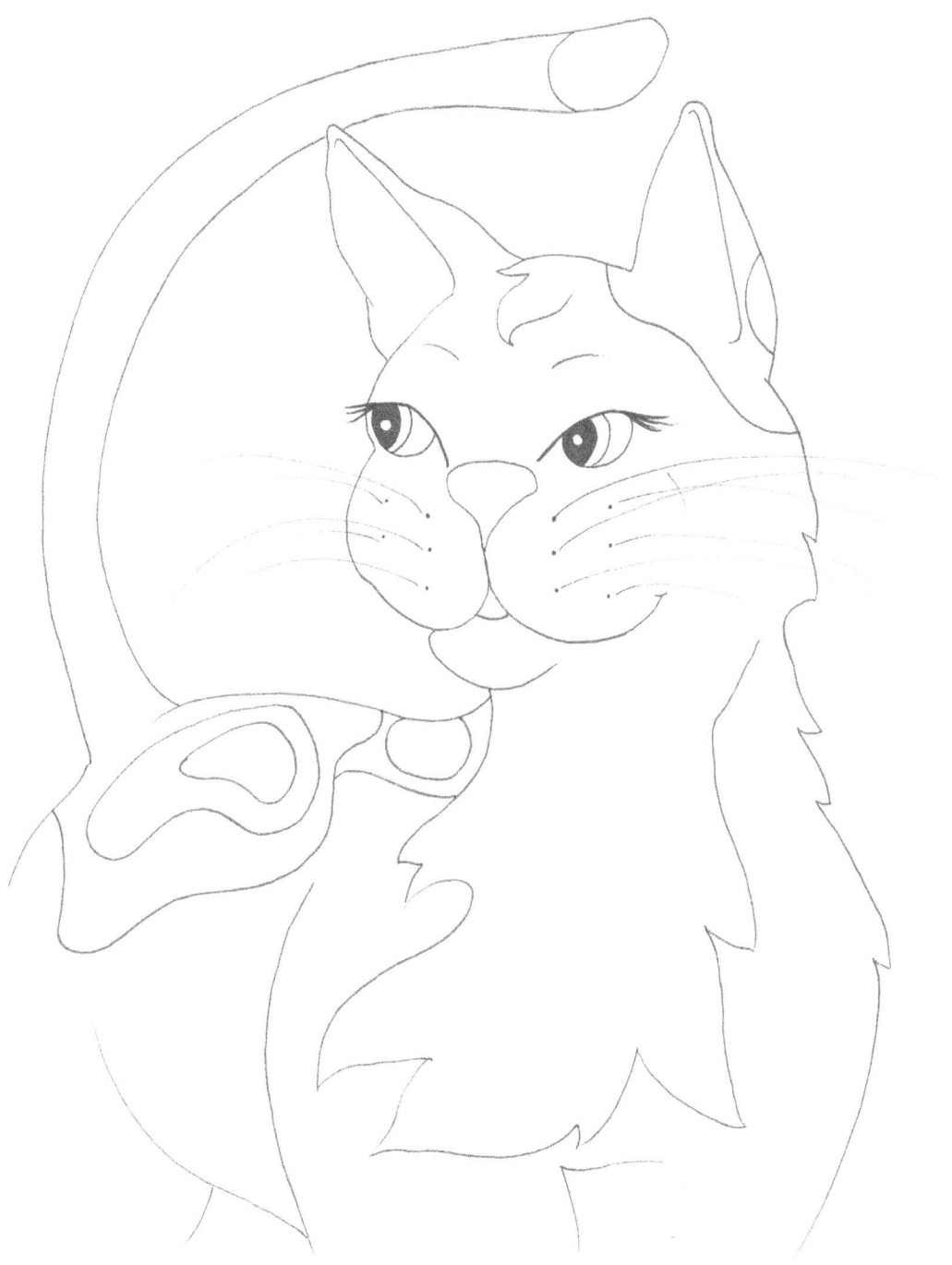

"Yes I will," said the _____ Cat.

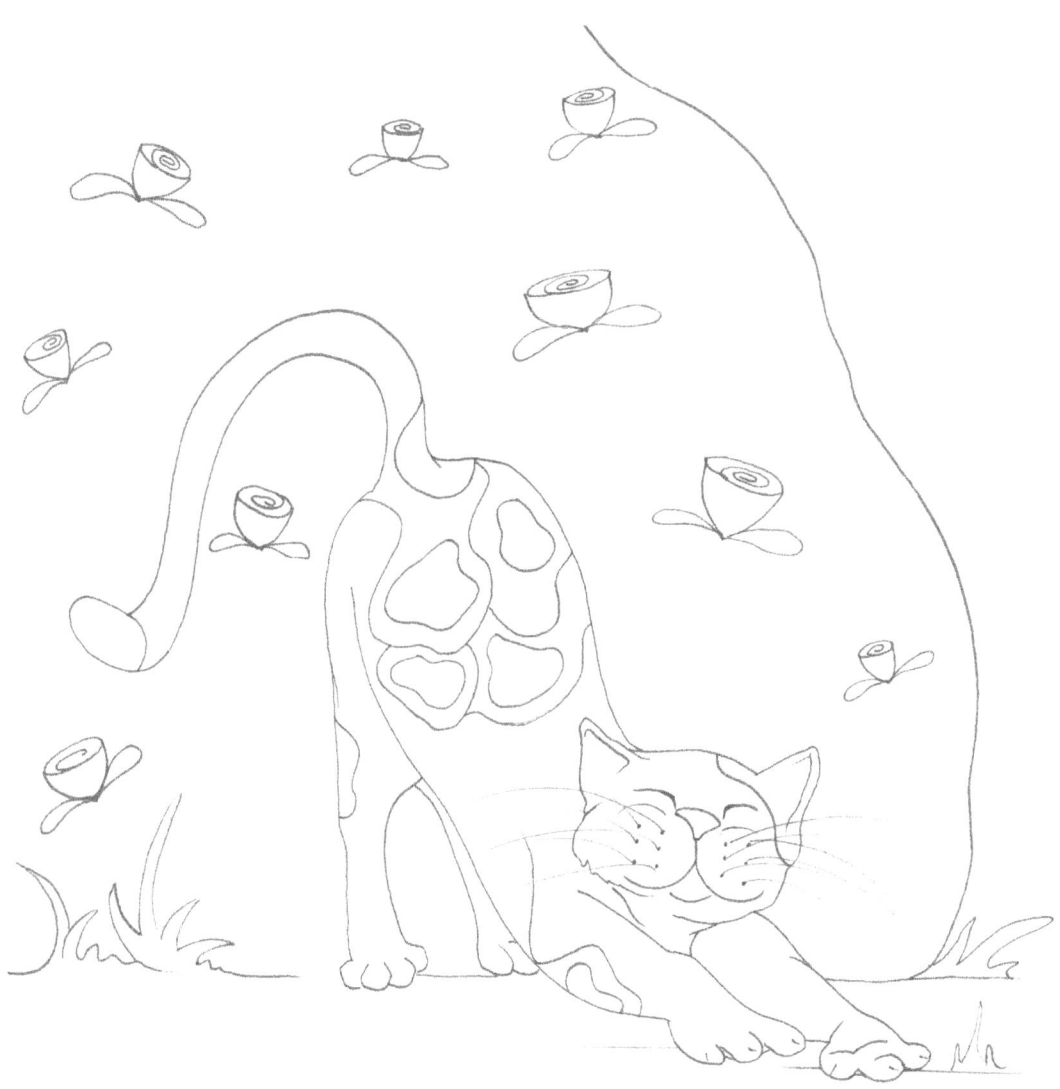

"I'm done relaxing."

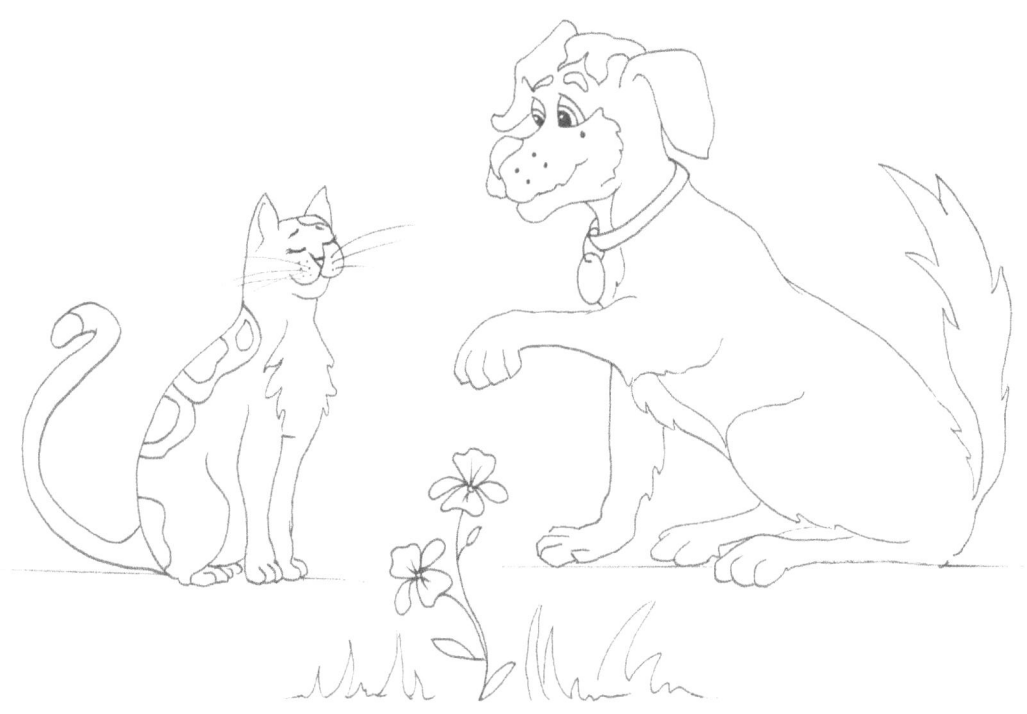

So the _____ Dog and the _____ Cat played in their front yard.

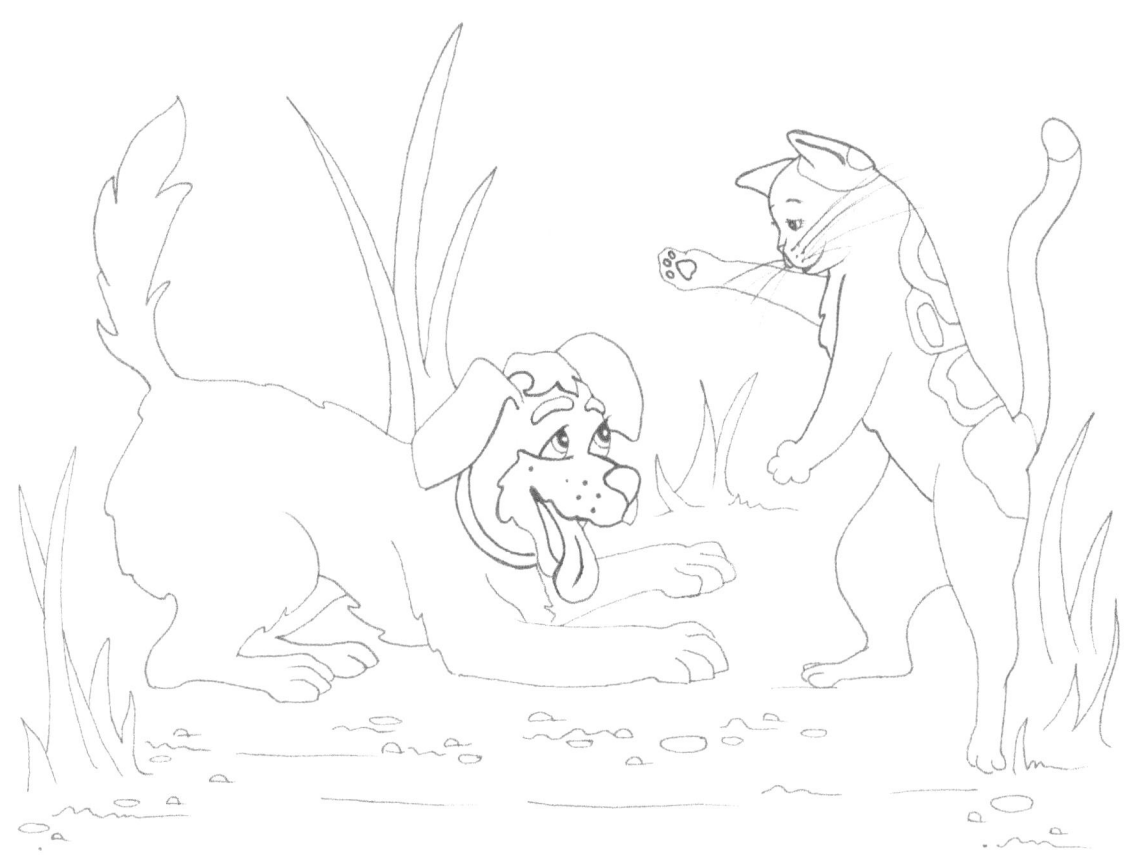

And they had fun playing together.

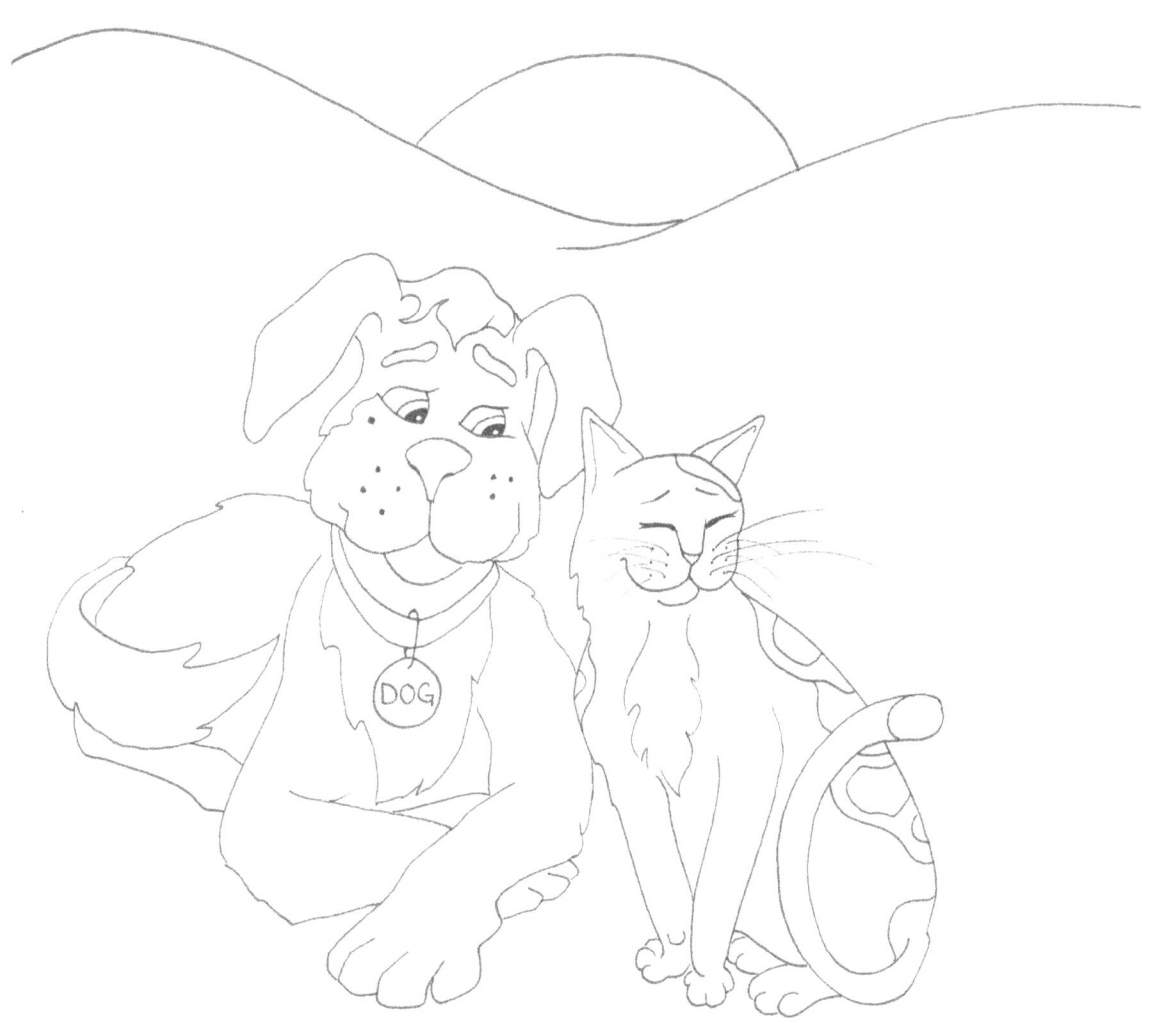

The _____ Dog and the _____ Cat played until the sun went down.

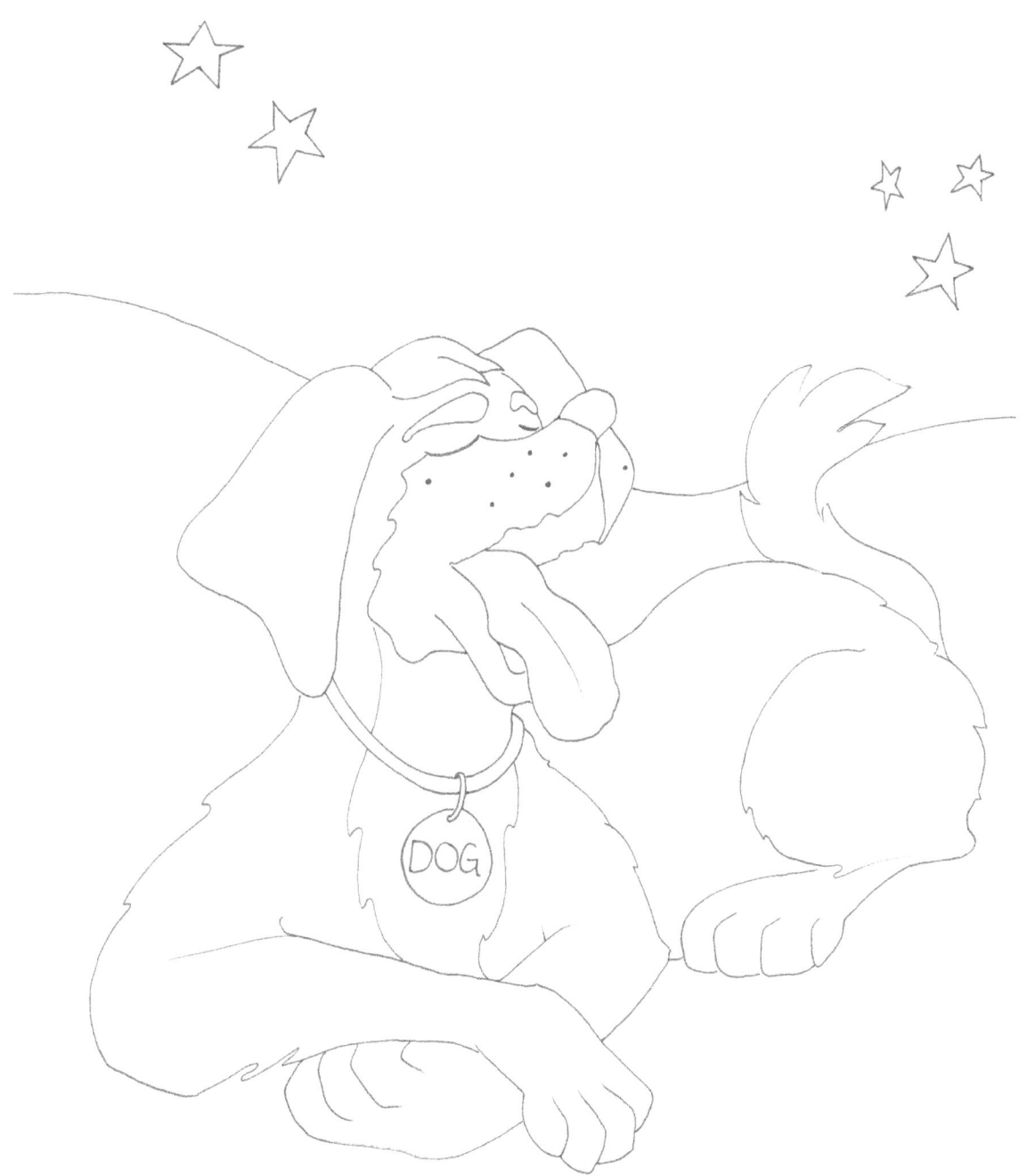

"I'm tired," said the _____ Dog.

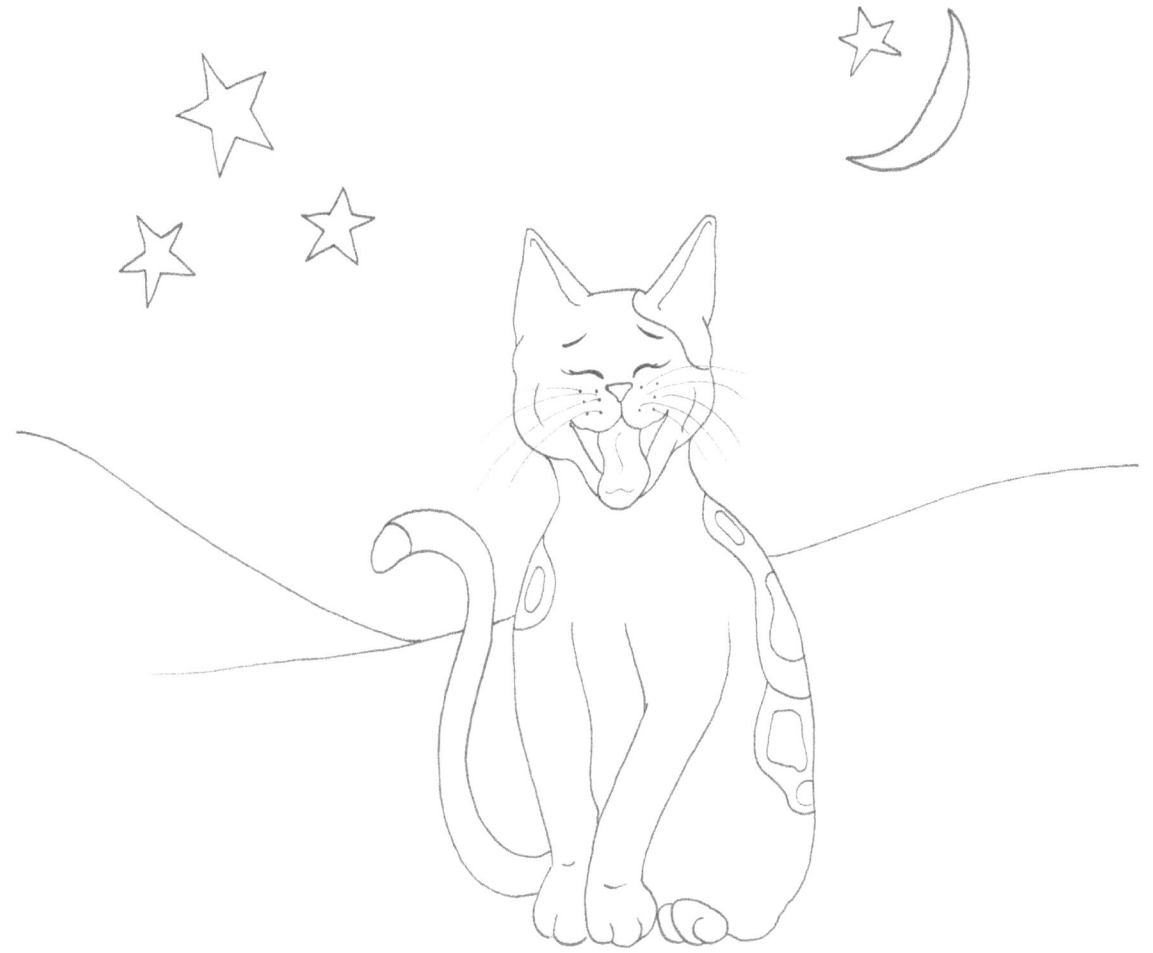

"Me too," said the _____ Cat.

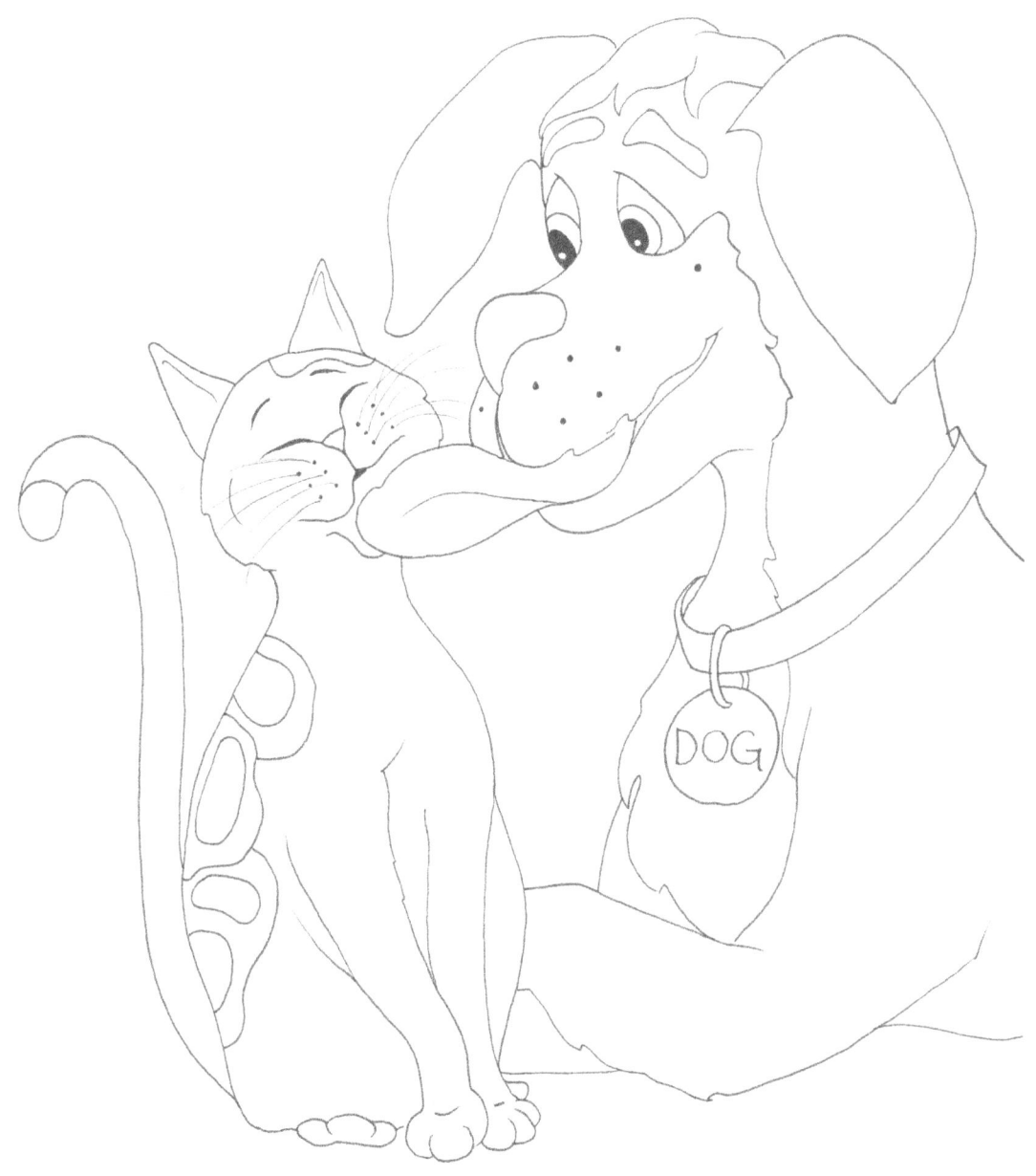

"Thanks for playing with me," said the _____ Dog.

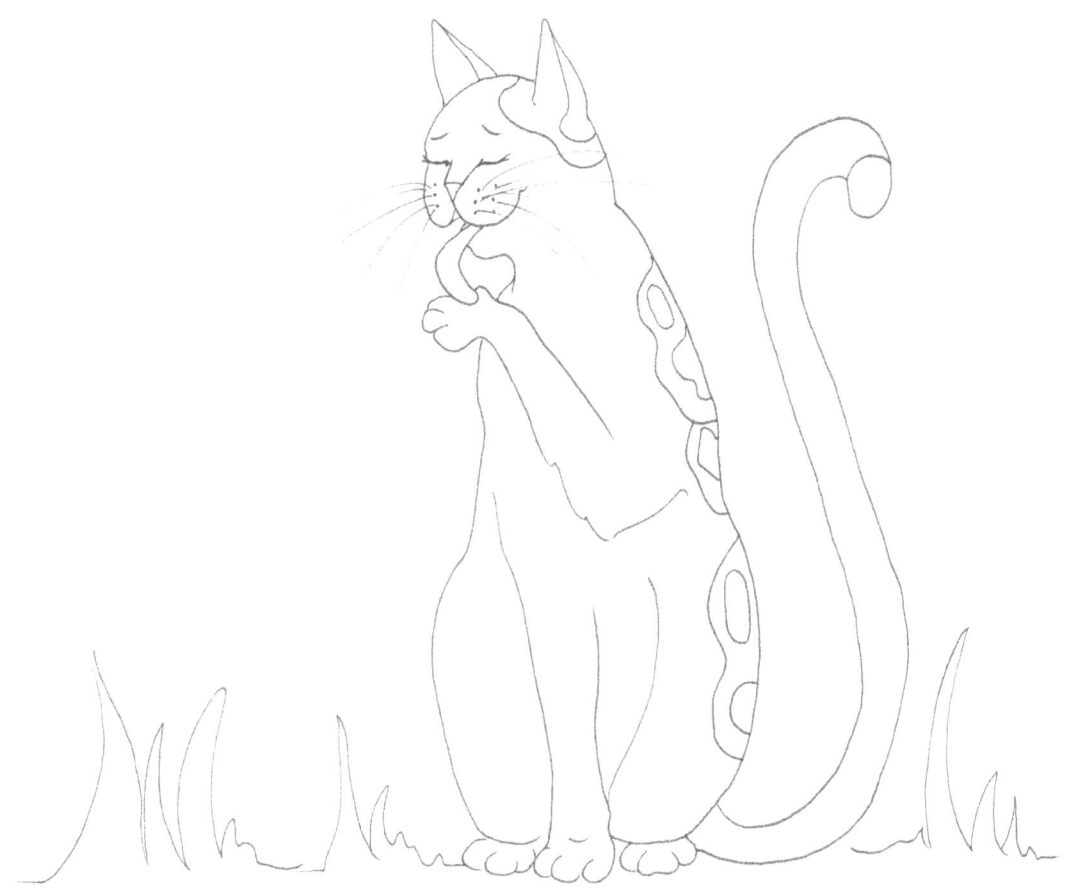

"No problem," said the _____ Cat.

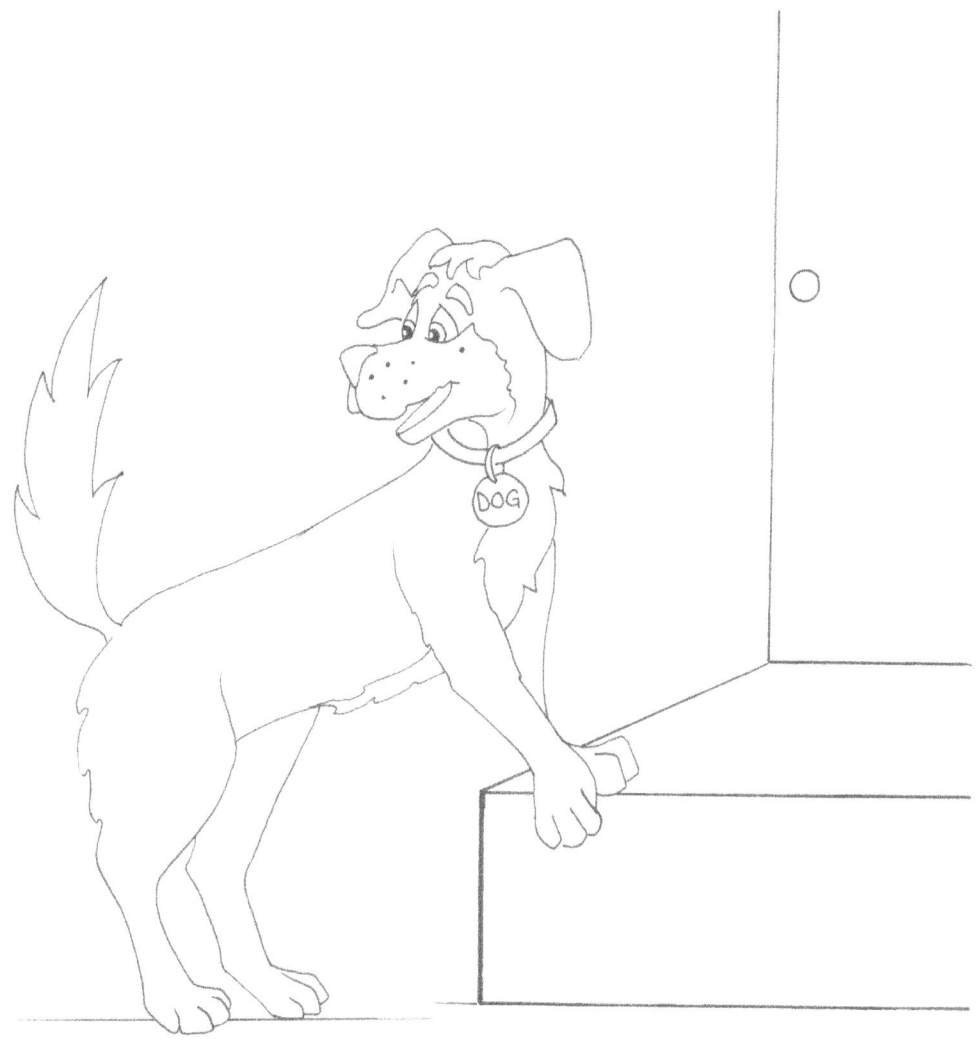

"Goodnight my friend," said the _____ Dog.

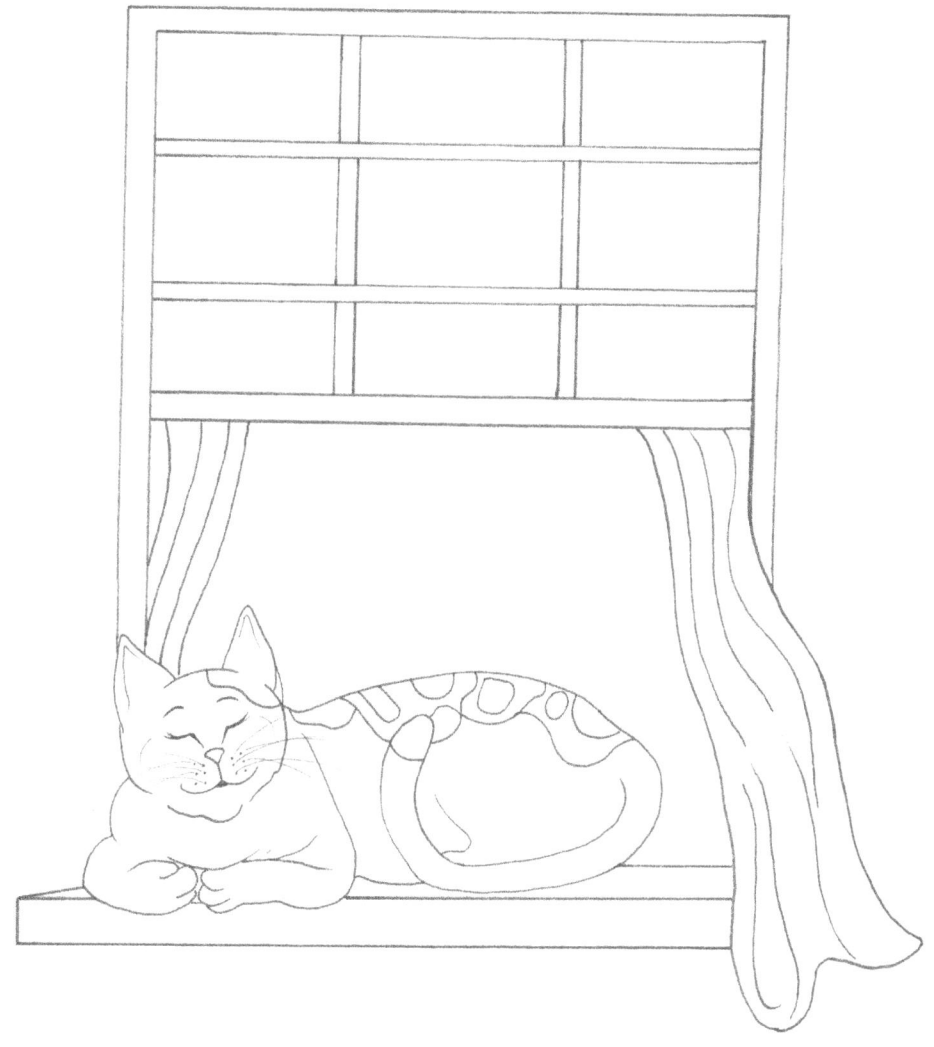

"Goodnight," said the _____ Cat.

The End

Acknowledgments

I first want to thank God for everything that He has done for me. I want to secondly thank my wife, Tara Murray for always standing by my side with every new project that I take on. I also want to thank my team: Carole Robare my illustrator, I want to thank Nico Maggi and Peter Alas our investors, for taking a chance and investing in our book idea. Together, this book is our creation.

Lastly, I want to thank my wonderful editor Ericka Kent for her guidance with each project of mine; and her patience with my work. You are a wonderful editor Ericka. Thank you to all who have purchased this book, I really hope you enjoy our style and have fun with the story. Manipulate it however you please. And remember, life is an amazing adventure; friends give you stories.

Bonus Rounds

Color Me

Crossword Puzzle

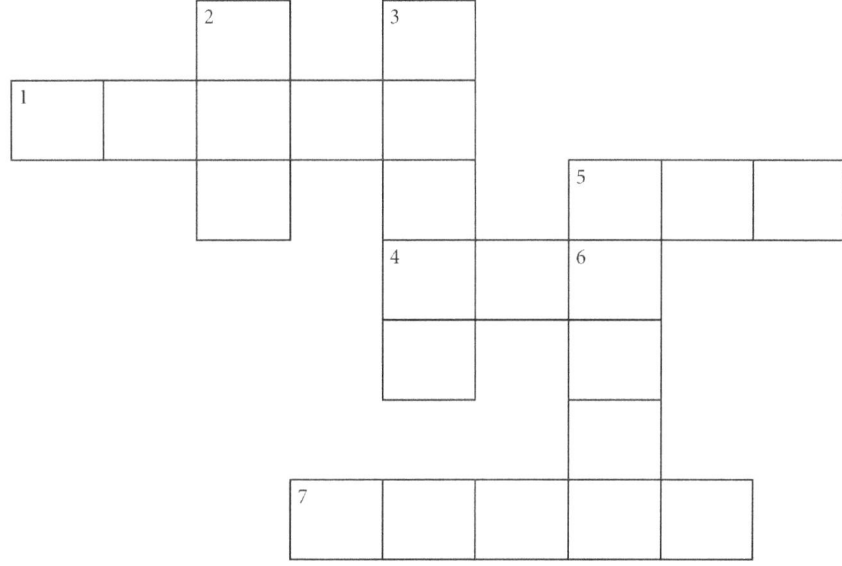

Words:
1. sun
2. house
3. Fence
4. Sky
5. Cat
6. Grass
7. Stars

Clues:
Clue 1. I stand tall on stable ground, family lives here, and I have windows for my eyes.
Clue 2. I sit high in the sky during the day, and I shine so bright.
Clue 3. I surround a house, I am wooden and I create a barrier around.
Clue 4. I like to play, I walk on all four and I meow.
Clue 5. I look over the land; the sun, moon and stars are my friends and neighbors.
Clue 6. At night, I surround the moon. I only come out at night.
Clue 7. I am green and I am on the ground. I'm not dirt, not mud, and not bushes. I look good in parks and in the yards surrounding homes

Match up the characters with their letters.

Characters

1. horse _____.
2. dog _____.
3. cow _____.
4. barn _____.
5. moon _____.

A. I bark and I love to play.
B. I'm black and white and I make a "Moo" sound when I talk.
C. When the sun goes down, I appear at night in the sky.
D. I'm square shaped and I hold food and supplies for animals and people. I'm not a house though.
E. I have a long tail and I love to trot. I have hooves and some people say they use my shoes to play games with.

www.ingramcontent.com/pod-product-compliance
Lightning Source LLC
Chambersburg PA
CBHW081852170526
45167CB00007B/2990